Today's Specials

Today's Specials

Poems

Sara Ries Dziekonski

Press 53
Winston-Salem

Press 53, LLC
PO Box 30314
Winston-Salem, NC 27130

First Edition

A Tom Lombardo Poetry Selection

Today's Specials
Runner-Up: Press 53 Award for Poetry

Cover image, "Woodlawn Diner 41,"
Copyright © 2011 by Brian Ries
Used by permision of the artist

Cover design by Kevin Morgan Watson

Library of Congress Control Number
2024934662

ISBN 978-1-950413-80-5

For my hardworking father, mother, and brother,
and for the patrons who lit up our little red diner—

but especially in memory of my sweet, magical mother
whose love filled us fuller than any food

Contents

Our Diner's Red

neon sign hums while most
of the world slumbers, metal-panel
gown aglow in the sunrise. Rust.

Ketchup with drowned bits of home
fries and sausage link butts, the scrambled
days of lightning lunch breaks.

Cracked knuckles of factory workers,
tomato soup sweating in the steam table,
my raw hands when I scrub the pots and pans.

Strip steak my father slices then slaps
back in its blood. Paprika. Diner bones.
Newspaper headlines.

Wednesday's special:
Beef lasagna, with sauce that dots our shirts
when we stand by the stove and stir.

The penny gumball machine
by counter one. Grill press to my chest
when a customer won't say thank you.

Luden's wild cherry throat drops
in the smudged glass jar above the grill
my brother and I suck on like candy.

My father's face when I forget to hang
an order. The ring *rings*, rush of a full
house. *Order up.*

The smell of liver & onions, strawberry
rhubarb born from the oven. My mother's rouge,
her full-hearted *Hello*. Diner love.

The silent worker
who could rub two words together
and make a fire.

Fish Fry Daughter Returns

Maybe you've heard this story:
I was born on a Fish Fry Friday
in November's icy grip.
When the call came, my father stayed
at the Holiday Inn kitchen
to fry fish for a party of seventeen.
He made my arrival
with seconds to spare.

When all the platters were packed with fish
coleslaw, mac salad, tartar and lemon,
my father threw off his apron,
hopped in his *piece of junk Chevy Vega*.
That was the last time it started,
its next stop: bones in the junkyard.

I'm sure he noted the moon,
how it must have hung heavy in the sky.
He'd curse *slowpoke* drivers
all the way to Mercy Hospital,
where he'd say thank you at least twice
to the nurse who directed him to the room,
told him, *Get there—right away.*

Maybe you've heard the poem that ends
with the hope my father held me
in haddock-scented hands,
apron over his black pants sprinkled with flour
forehead oily from standing over the deep fryer
telling the fish to hurry, *hurry*—

Here's another ending:
I arrived with the umbilical cord wrapped
around my neck, my first necklace:
miracle baby, the doctor said.

I was born from the pull of my mother's longing,
the stretch of time where my mother laid in a hospital bed,
gown sticking to her skin, her hair a tangle of golden leaves,
nurses asking, *Where's your husband?*

When my father finally got there
my mother said, *What took so long?*
not to him, black hat coated with grease,
but to me.

American Cheese Family

Dad always brought food home in buckets
from our diner. My brother and I grew up
licking grease off spoons. We ate between customers;
our clothes were napkins—we got the job done
sometimes. Because when I ate ribs,
Dad would show me his shiny bare bones, point to my plate
and say, *Still good grub on yours.* That's why I quit meat.
Cleaning the bones was like rummaging
through the top drawers of the deceased.

I was jealous of other kids' lunches.
They came in ironed brown bags, everything
so tidy in Ziplocs or Saran Wrap.
The food I carried in plastic grocery bags
slouched in bunched-up wax paper.

I couldn't help it. We were an American cheese,
chicken a la king, pork & sauerkraut family.
I never tasted brie until my address was no longer theirs.
I brought some home for Mom to try. She said,
Shit, Sara, this is good, and began buying her own,
stashing it away from my father's eyes.
Because if Dad saw, he'd say, *Joan!*
How much did that dinky thing cost?

During a visit home, Mom pulled the brie
from under the pale green lettuce and whispered,
Look what I got, and we ripped a piece
for every secret my mother kept,
for my own wilted words that never leave lips.
We shoved even the mold into our mouths

until Dad's black truck grumbled up the driveway.
Between the curtains, I watched him unbuckle our dinner
from the passenger seat. It was spaghetti
and sure, Mom and I had some
but when our eyes met across the table
all we tasted was a creamy, buttery wink.

Dad Taught Me Poetry

It's lunch rush.
Dad and I dance
too fast for grace.
I have soda & syrup
hands, egg yolks
on my shoe tops.
Dad, butter on glove,
places fish on platter.
I say, *Ralph wants*
the sandwich—
I thought I wrote it.

Dad's face turns red,
older. I picture him
in a hospital gown
and we are laughing
about times like these.

He grabs the fish,
throws it back
in the pan, huffs.
You gotta pay attention.
Our words are weeds.
They tangle and seal
the doors to our ears.
I rip the fish, place half
on a roll and say, *Done.*

At our diner,
the grill smokes behind
the counter, and we
are underpaid performers.
A customer says,
We all make mistakes;
we're only human,

and I picture myself
slipping out of my skin,
the warm pile left
to be swept then mopped.

Because we can't talk,
only yell for hours until
I raise the Closed sign
like a winning lottery ticket,
Dad hands me a note
on a piece of register tape.

His words:
scrawled stanzas
down the skinny paper.
I write my explanation
in short choppy waves
with the intent to drench,
and we go on exchanging
these scraps of poems,
dining room to back
kitchen, back kitchen
to dining room

until we find our way behind
the curtain of words, feel
what each other meant,
raw and simple, as one by one
the words that guided us here
disappear, and that leftover
silence
is the poetry.

The Diner Is Up in Flames

and all the customers just sit there,
somber statues in a row
of booths the color of pews,
 my father, the priest at the altar.
They sit with folded hands,
waiting
for my father to cook their last meal. I
am floating near the ceiling,
observing the way I do in dreams.
I descend to the grill and scream
 bloody rare bullets
into my father's face: *Get out of here, hurry—*
But Dad refuses to stop.
He's got orders to cook,
and, they don't call him
Super Dave
for nothing.

My Mother's Jet Plane

The jukebox slots are taped at our diner
so that people don't lose their quarters,
but I still hear Mom's song as she drags herself
to the same old coffee pour—May I Take Your Order
dance. At each booth, Mom shines the records' steel caskets.
The lights in her face are off.
Her hair, clipped wings.

Before our jukeboxes died:
Mom punches E7: "Leaving on a Jet Plane"
over and over when she's sad.
Customers slurp and chew, bob their heads,
tap mud off their boots *I'm leavin'*
on a jet plane Don't know when
I'll be back again. Mom scrubs the blinds
and watches cars. She assumes they wheel happy people
to better places than this diner, these rusted red bones.
She scrubs until someone says, *Joan, can I get—*

People need so many things just to eat.

When I lived at home:
Sometimes, from beneath me, I hear sobs.
Mom's in the basement again
sitting on a dusty exercise bike.
I ask, *What's wrong?* She says,
I can't do the diner when I'm down
but your father needs me. I want to tell her

now is only one of your dances.
You will be manic soon.
Customers will say, *Okay Joan, twist my arm,*
and you'll overflow their mugs
and draw whipped cream smiley faces on pies
just to die for.

And we will wait, Mom,
for clouds to ground your radiant jet
for your *Leaving* song to skip, for you
to come home.

Country Music Wally

Flip back
to my first chapter of memories:

Wally, the neighbor, shakes his finger
at my brother and me, says, *Now don't you move
until I get back, you hear?*

So we sat by our shoes
and tapped our knees in the tiny coatroom
of our grey home. We told Mom,
and he never watched us again.

Now Wally is a regular at our diner,
and every Saturday, once he's devoured a hot
meatloaf sandwich, gravy good and smeared
in the bramble of his beard,

he adjusts his suspenders, limps to the cash register,
hands clutching his walker's handles,
jeans rolled above Velcro shoes.

I want to ask
*Where were you off to when I was four
and my brother five?*

But instead I ask,
How was it?

He snickers. *Well, I ate it,*
pats his flannel belly.

He pays.
I hand him change, wish him
a good one.

His palms are shriveled maps
with patches of wrong turns.

He gives me
a dollar,

and week after week,
I back up as he spits soggy bread,
says, *I ain't gonna do nothin'*
but sit in my recliner,
watch country music videos, and fall asleep.
Yep, nothin'. Less I move, the better.

See you next Saturday, I say. He chuckles.
If I'm alive, you will, and I stand, still,
until he's a shadow.

The Urine Couple

They shuffle into our diner
just as I sit to eat.
Their shopping bags bump cruddy jeans
with each step to the last booth.
I wrap my sandwich;
they unbutton their jackets,
slowly, as if they don't expect to stay.

I must tell them to leave
before their arms are bare.

I run to the kitchen. *Mom,*
those people reek of pee—
they have to go. She stirs the chowder,
taps the ladle to loosen some drips, says,
Sara, no, let them eat, turns off the burner.

Mom, the only reason they're here
is because they can't go anywhere else.
She doesn't answer, just puts on gloves
to cook their order.

I grab my pen, storm to their table.
Know what you want? I say. I am yanked
into ammonia the way men sometimes grab
other men's shirts before striking.

She mumbles, *Eggs & toast, please.*
He says, *The same, please.*
Their heads stay down,
no gaps between their skin
as if their bodies crave the fact
that they have each other.

A hair pokes through her mole.
His beard is grey, slick and shiny.
Their hands stay held.

Their backs face us
so they don't see when Ralph
brings the paper closer to his nose
or Gale clicks a heel, swings
her head to identify the stench,
asks for her food to go,
or me, ducking behind the counter
to hack the piss from my throat.
Smell it? I ask Mom. She says, *No,*
then goes out of her way
to walk by the Urine Couple.
She says, *Hello.* They nod
with heads down.

I nudge Mom. *Now do you smell it?*
She cracks an egg, says, *No,*
and jabs the yolk with a spatula.
I serve them dark triangles
above over hard eggs
and power walk away.

After every customer and insect leave
they quickly button their jackets. Bags bump
their ripped jeans with each step that takes them away.
I clear their table, pull a dollar from under a mug,
and give Mom the half-wrapped butterscotch;
she tosses it in the trash.
I unwrap my sandwich and say,
I can't believe you couldn't smell that.

She grabs the Lysol,
sprays then scrubs
everywhere
their bodies touched.

Milkshakes

They sit at our red diner's counter
sharing an extra thick milkshake
through straws that make a V.

Brian and I shorter than the counter
when our parents bought the diner
never drank from those tall curved glasses,
only from metal tins when a waitress made extra.
But April is the kind of woman who exclaims,
Brian, let's get a milkshake—
how could you say no to a woman whose name evokes
puddles, bird song, and blossoms.

I imagine the diner is a sweets shop
and they are behind the counter testing sugared pecans,
berries dipped in honey, and coconut clusters,
feeding each other their favorites,
giving away handfuls to customers.

The milkshake is gone and the jukeboxes broken,
but they shine to the rhythm of waltzes.
Dad flips the bacon, bubbles floating into booths.
Mom refills their waters,

but they don't notice. They must be dreaming of a road
lined with sunflowers tall as trees, her hair tossing the wind's secrets
onto his strong shoulder.

Teenage Waitress

I was still getting used to my hips,
which developed wide so they'd ram
into curves of counters as I'd swing around corners
with coffee & creamers in my parents' diner.

Two men at a back booth eyed me
up and down. The scruffy beard asked,
Can I get anything on the menu?
I said yes. He asked if *I* was on the menu.
I laughed. They sat with one knee pointing,
claiming me like an arrow.

The other man motioned to their rusted work van
parked behind my father's pickup,
said he had handcuffs and whipped cream in there,
that he'd get them if I wanted.

They wore slimy smirks
and gaping mouths.
I wore a t-shirt and jeans
if you must know.

I laughed, not knowing what else to utter.
I could taste the filth that covered them.
The words I should have said were wedged
like crumbs in the booth cracks. It was the day
I learned to wither, become smaller,
so there was less of me for the taking.

I told my dad. He was cooking faster
than a shoeshiner polishes. Beneath a line
of hanging guest checks, he huffed,
shook his head. He did not have time for this.
I couldn't tell if he was mad at me or them.

These are the stories that stay with us
like infections that won't heal;
gum stuck under the countertop
which goes with the counter to the landfill.

I served the men their sandwiches.
I could feel their eyes on my ass as I walked away,
and my body blamed itself.

They left and never came back,
but it wasn't my father who told them not to.
He went by the saying:
The customer's always right.

My father never kicked anyone out of our diner,
not these guys, nor Don, who I'm sure is dead by now.
Once when I was eating chocolate chip pancakes,
he towered over me and said,
Watch your shape.
You're looking more and more
like your mother.
Then he looked at her, back
to me, said, *Fat is ugly.*

But that is another poem, and another kind
of shrinking.

Ketchup in My Veins

After George Ella Lyon's "Where I'm From"

I come from cleaning rags born
from old clothing, I Can't Believe
It's Not Butter, the blackberry bush
where our pet cats are buried,
weeping willow that sometimes swept up my sorrows,
buckets of food brought home from the family diner:
goulash, mac & cheese, heavy cream soups,
and we scarfed down sandwiches
with fries and globs of ketchup.

I'm from diamond-shaped windows
that birds sometimes smashed against—
I held my breath and sprinted to the bushes,
hoping not to see another
broken-winged body
with the notes streaming out of her.

I'm from loud talkers and interrupters,
bumping-into-each-other family reunions,
sincere please and thank yous, hugs that squeeze
out breath. I'm from *whoever eats the fastest gets the most,*
church every Sunday, or *you better talk to the man upstairs,*
the tangled rosaries under my pillow—One night, I held them
and slept through the night again.

I'm from the mother who signs every note with streams
of x's and o's, the father who makes the rules,
and his sister with the Goldilocks curls
who, before I was born, hitchhiked
and was never seen again.
(And the cigars my grandfather silently smoked,
his silence that became its own conversation.)

In the dusty corner of my closet:
a photo album from when all our relatives
could be together without someone dying,
from potlucks in Grandma's backyard,
the cottage on Chautauqua Lake.
I am from these moments—
in dreams they rustle like clothes on the line
that smell of soap and wind—
ketchup stains lifting to the sunlight.

Racecar Dad

Doritos smeared on our faces,
glittery polish caked on cuticles,
Sherri set her dead hamster's cage on her dresser
and nested seeds, fabric, and a bottle cap filled with water
between the silver bars.

I had just brushed my teeth
when Sherri clenched my hand—*Shhh,*
I have something to show you, but don't tell anyone,
promise? She opened the top of the cage,
pointed to thin shadows spinning across the cloth
like a merry-go-round.
See them?
They're spirits.

Even I, the gullible one, knew they were only
shadows from her ceiling fan,
and when her father died ten years later in a car that was going too fast,
how I wished that again and again for her
retrieving him would be as simple as
setting up some sort of box with his gold watch and a book,
poking holes in it, to let her daddy in—

He came in and said, *OK, girls,*
time for bed, and we slid under sheets.
He kissed her forehead, said, *Freckle Face,*
how do you spell racecar backwards?
but before she could say *r- a- c- e- c- a- r*—
the sleep train carried her away.

Postcard from Scott Spencer

Dorothy, the mail lady, delivers
the postcard as I decorate
for Christmas. She says, *No bills today*,
tracks snow across the long black doormat.

Just this morning I asked the other waitress
if she'd seen Scott. She said, *Who?* and I replied,
The trucker, camps out at counter 9,
brings us the jumbo light up pens—
she slid a tip in her apron,
shook her head.

I stick Santa to the window
and think of Scott, alone in his semi.
I imagine headlights: icy rivers down dark roads.
The highway bare and breathless.
"Silent Night" on the radio,
Scott switching the station.

The postcard has palm trees
with bubble letters that spell Florida,
and the flamingoes wear oversized sunglasses.

His words are like boot prints
across the postcard's white sand:
> Dear Sara,
> I never know where I'll be from day to day.
> Last New Year's they sent me to Long Beach
> and I watched fireworks from a bridge.
> All my life, firework shows have been kids
> with sparklers. But these fireworks, honest to God,
> shook me. Maybe I'll get lucky again this year.
> > Happy Holidays, Scott.

I pour everyone more coffee.
This I'm sure of: today and tomorrows,
I'll trudge these stories through snow
until it's gone.

Trucking with Scott

Scott clambers down from the only home he's got, — his big rig,
before he tracks in mud and settles at the counter, — where I'm
signing guest checks. As he orders I taste — a triple decker whiff of
sweat crud and pinching skin — to stay awake.

I study the pins on his sweat-stained hat: — bottle opener, gold semi
that says — *Keep on truckin'*, blinking happy face, — and just above
the extra curved brim: a dime-sized picture — of his daughter. I pour
his coffee; he asks for cow.

I extend two handfuls of creamers, say — *I still want to go trucking
with you* — and he slaps the counter, rattling — the antique cans
with his laughter. — *Can't figure that one out for the life of me,* he
roars. — *It's for research*, I remind him, and he warns — *Still better
bring a bucket to pee in.*

Before bosses used GPS to track delivery workers' every — movement,
Scott would stay for hours, order a steak, — then a large milk, then a
burger, and after a while, — pie with more coffee.

I take Scott's empty plate, so he has room to line up the photos —
from his fanny pack. His jaw hangs heavy, — his stare screams sleep
deprivation. — He points to the same old photos I've memorized:

the tall one with hair the color of embers — who begged until he
bought her a car, — a woman in cut-offs who calls him Sugar, —
the cashier who only rings when she's lonely. — The series of his
daughter, and her two daughters, — in Florida, but his truck route
changed, — so he doesn't travel the deep South anymore.

He pulls out another, a new picture. — It's of me—clearing a dirty
dish. My stomach scrunches. — *Your ma gave it to me,* Scott says,
— spitting toast crumbs onto the beige counter. — He checks his
watch, says, *Oh, gotta run. — They've got me on a tight leash now.*

Scott tucks the photos, including me, — back in his fanny pack, zippers it shut.

Now, in diners across the country, — (Scott says they're getting harder to find) — bored waitresses lean on counters, and when they get — to my photo, Scott says: *This one here—That's Sara. — I stop at her parents' diner when I'm up in Buffalo. — She's a writer, has a book, and get this — she wants to go — trucking with me,* and he laughs so loud — a baby cries.

Sometimes, when I catch a whiff of my own stale skin, — or my mouth is rancid and heavy with exhaustion, — I imagine I'm in the passenger seat, — passing Scott the peanuts, shouting his name — to be sure he's not drifting to dreamland — and we're not heading to deathland.

I'm curious about showers that start with quarters, — and the contents of those claw machines. — But mostly, — I want to know what it's like — to travel the conveyor belts of time — for so many miles, so many miles of soaring down highways, — pavement and yellow lines.

I need to know, how many miles does it take — for the road to become a vein that transports wind, salt spray, and insect blood

to the heart of our own — damn longing.

Woman Truckers' Poem

*from NPR's article, "Truck Driving Has Long Been A Man's World.
Meet the Women Changing That"*

She drives a week,
makes a thousand.

Quick dollars.
Sees the country

from the cabin,
no manager over her shoulder.

But also sleeps in cots,
risks blood clots.

Among the most dangerous
professions

is hauling 70 feet of truck.
The first climb up

everything looms bigger—
mirrors, wheels, gearbox—

more intimidating. At gas stations,
some men throw smirks or side-eyes.

It doesn't bother her.
Her mother also drives.

Hear her say, *Sexism on the road
doesn't deter me from driving.*

Hear her say, *Guys,
you better watch out*

*'cause from now on
this right here*

is a woman's industry.
Turn the key, change gears.

Feel the subtle shift
in the engine's powerful rumble—

Dear Myles,

I set your sandwich between your forearms
and said, *I don't like to read fiction;*
I'd rather read poetry. I thought you,
professor of literature, would be disappointed.
But your grey eyebrows raised,
making your plastic brown glasses
jump. Palms up, you straightened
your fingers and said, *Then just read poetry.*

Another day, you extended
a story-filled hand,
gifted me a bag of poetry books,
old ones, like you, that have been
touched and loved so many times.
Out of breath, you tapped your cane
and said, *I walked here. Small tasks*
keep getting harder, but I made it.

I untied my apron, joined you
at a booth, handed you some poems.
You pulled a toothpick from your turkey club.
Do you think I could be a professor? I asked,
and you said, *Now why would you do that—*
you have poems to write.

Once, when you could no longer walk
to the diner, you took a cab
and sat for hours until my shift ended
and I could drive you home.
I said, *Shouldn't be much longer,*
but the door kept opening. *I'm in no hurry,*
you said, and sometimes, as I poured
someone's coffee or wiped a table,
we met eyes and smiled.

I drove extra slow,
parked in your driveway.
We did not unbuckle our seatbelts.
Instead we talked for over an hour.
It was our last conversation.
It was the middle of summer.
I had chili caked on my apron.
Your hands were folded wings.

You said, *Send your manuscript.*
Send it everywhere. It seemed urgent.
I jotted a reminder on my hand.
You said it again. Because you were tall,
your knees made a V, head brushed my roof.

I said, *Do you really think it could get published?*
You replied, *I don't know that, but I do know*
I couldn't stop reading it.

I told you I had a reading last week,
but I showed up late and everyone waited.
You took a deep breath and smiled.
Your cheeks, a touch of strawberry.
Get to places on time;
then you will get published.

We both don't know this yet,
but Myles, I will win the contest!
My book will be published.

And then, the click of your seatbelt—*I better go,*
you said, and slipped into the summer air,
your breath drifting back into the open windows,
a sonnet that keeps on lifting.

How We Said Goodbye

for Myles Slatin

We sit in a tall-backed booth
in a diner where I'm not your waitress.
We are in my dream, and *Myles—*
it's so good to see you! It's been months
since you came to our diner
and I kept checking the obituaries.

You place a hand on mine—
60 years between them.
Your other one shoos a fly.
They are hands that shook
as you fumbled for your change
to pay the bill.

I take a sip of coffee
and say, *Good coffee.*
You look disappointed—
time has closed for small talk.

Have you been writing? you ask.
Yes, I say, then remember the poems
waiting to be watered.
I can't tell where the table starts,
so I set my mug down hard.
I'm slowing down, you whisper. Then
your clock's numbers lose their grip,
feathering as they fall. *I don't want things*
to be hard anymore, you say.

You close your eyes and inhale
all the years of your life.

Myles, Myles—I need you.
We both stand up to hug
and do not let go
until your clock's hands reach
our feet.

This hug is a poem, I say,
I have to write it down.
You have no use for paper,
so I write by holding you harder.

My shoe tips over yours,
I squeeze you and say, *Myles,*
this is our poem, and you say,
Believe me, I won't stop reading it.

lady at the counter

for women who walk alone at night

sisty scuffles into our diner
with her usual bouquet of bags,
orders iced coffee
in the dead of winter.
she unlids a new batch of questions.
today she wants to know
what i think about when i swim,
what my parents are like,
if anything about my childhood
bothers me, if i laughed a lot,
what i found funny.
i grab more ice for her coffee.
she orders a second steak dinner,
says, *when i'm upset, i eat,*
her boots crying dirty tears
of snow onto her bags.
i have ice cream most nights, i tell her
to make her feel better.
she presses her palms together,
leans her chin on her fingertips,
says, *when my mother died, i ate*
a half-gallon of ice cream,
and for a while, i did that every morning.
i serve her steak, pop a roll in the microwave,
fetch a handful of gold-wrapped butter pats.
she says, *i don't drive.*
i like to walk, alone.
i just walk and walk, sometimes all day.
i know, because i see her all the time,
sometimes at three in the morning.
weeks later, i'm eating my shift meal
and spot her lumbering down the avenue,
bags bouncing off thick thighs,
hatless, her short grey hair

dusted with snowflakes.
maybe you, like me, think
she's a woman walking alone at night,
she must want company.
i run outside and invite her in.
skin shining with the glow of streetlight,
she smiles and keeps walking.

Cigarettes, Meat Fat & Ice Cream

I.

Every Saturday, Uncle John rang our doorbell,
and from my room I listened
for galloping feet, click of the lock.

He never ate dinner at our table,
no matter how many times I pulled up a chair.
He'd say, *I'm fine right here*, stand by our shoes,
plate on the back counter. His greasy hair
combed, teeth crooked, chipped.
As I cleared our plates, he'd say,
The fat is the best part, claim our scraps,
except for the pieces I hid in my napkin.

He loved ice cream,
always asked for more
even when Brian and I piled it on,
laughing hysterically,
sure he'd never finish it.

Want to sit on the patio, shoot the breeze?
Sometimes we did on furniture he built with Dad.
I have a best friend, he said, as he puffed a cigarette. *Who?*
Chin lifted, smiling. *Your father.*
He smothered the embers in the ashtray, pulled another
from his stretched shirt pocket. Once,
when my parents were away, he lit one for me
and I told him my secrets.

At dusk, he'd give Brian and me a bear hug,
our noses trapped against his flannel
which reeked of stale sweat and Marlboros.
Dad rummaged through the fridge,
packed a bag with leftovers
to get him through the week.

II.

November, a week before I turned sixteen,
the grass wore a thin white veil; I couldn't stop shivering.
I heard Uncle John: *Eat something.*
He said this whenever I was cold.

When the doorbell didn't ring,
I sat by the window and waited
for his small black car
to sputter up the driveway,
dinner hardening under pot lids.

We searched for his trail:
pennies against the red house bricks,
a higher pile of cigarette butts.
Sometimes, if no one was home,
he left us little hellos.

Sunday evening, Dad took me
to Uncle John's grey apartment.
I followed Dad up three flights of stairs.
He knocked, then rammed the door down
and we went in,
the air bloated with final breaths.

He was lying in bed
in jeans and flannel and boots
on top of smoothed-out blankets.

III.

Dad sobbed as he drove us home;
the car swerved. He pounded his fists against
the steering wheel, cried, *My brother, my brother*—

and then, the clouds parted
and a river of light poured through.
There's Uncle John, Dad said.
I nodded, then searched the sky.

the customers never saw

the poem-pieces i scribbled then shoved
 in my apron pocket
 never saw
 dad napping on the cellar couch
 feet wailing in throbs
 a full stack of hours to go
 or mom:
 puffy, red, swollen
 sinking into that same couch
 for a sample of peace, escaping
 my short-fused father at the grill
the customers never saw
 dad and me at the stainless steel table
 a bus pan of potatoes between us
we peeled the brown coats
 from their starchy bodies
 sometimes
 feeling
 their hearts beat
 they never saw mom and me
 sneaking pies
 into the back kitchen to split
we'd return to clear our tables
 sweetness
 singing
 in our mouths
 good thing the customers never saw brian and me jumping
 in the dumpster to
 flatten
 trash
or me peeing in the stock room's drain
to avoid the dining room

and since we're on the subject
the time i hid
in my brother's shit
in the basement garbage can
hide-and-go-seek gone wrong
oh, and that game we invented—
lickorie—
where we'd launch
egg crates like frisbees
the customers never saw our small bodies
entering the garage with dad at 3:45 a.m.
on saturdays, sometimes to find
a mouse
on its wooden deathbed
never saw
the cots below the kitchen
where we cocooned until it was time
to sort silverware/ chop ham/ scrub pots and pans—
the customers never saw my father say
look at the sky
me kneeling on a booth
forehead against the window
the cool glass palm of morning
strands of sunrise lifting above bethlehem steel: our day's poems

I Explain to the Guy at Counter Eleven

in the greasy blue jumpsuit
in the sour breath of morning
when bodies ache to be back in bed sheets—

that we don't have orange marmalade.
We used to but stopped carrying it, I explain,
after swinging open the stainless steel door to check.

It's a yes or no question, he scoffs, and I lean in
so that my hair swings across the yellow gooey pond
of his Eggs Benedict.

I'm not a yes or no kind of gal, I say,
and before I can reach the other counter,
he grunts, *Typical woman*. I become

a quivering body filled with the weight
of women put in their place: my mother, told by her father,
Tape your mouth shut.

I hang an order with a shaky hand
as customers shuffle in,
and the diner fills like a platter at a cheap buffet.

Jan, in his two-decade-old purple jacket,
pushes his empty mug to the corner of the table
for the sixth time today.

For 32 years my dad, worn-out short order cook,
never missed a day that creaky door opened.
He would say to my complaints, *The customer's always right*

so that the comebacks I needed to utter
burnt in my mouth like the toast in the ancient toaster
Dad refused to replace.

I return to the man in the greasy blue jumpsuit
who's smearing profanities on my countertop
with his filthy elbows. I ask if he's set with the coffee,

or if he wants one more for the road. He seems surprised I'm asking,
says, *Yes*. I look him straight in the eye as I pour,
stopping the flow with a quick flick of my wrist to send

some brown tears flying. I say,
I hope that wasn't too many words for you,

then take his yellow-streaked plate and leave
the black crumpled napkins.

Sweet Sixteen

I.

I remember walking to the golden arches
and not the yellow bus, how he pulled up
right on time in his tan pickup truck. I got in.
I twisted my hair and fidgeted with my backpack strap,
thinking *I am not the kind of girl who skips school.*
I remember feeling slanted like my mother's forged signature.
And starving, but believing I was sexier
with my stomach flat. He lectured on his new truck's features,
and I counted the trees whizzing by on the 219 as we drove
to his house in the country. When he turned
his front door key, I thought *he's so cool
with his own place and big truck.*

He went straight to the TV,
slid a VHS into the VCR, pressed play;
then he kicked off his shoes.
Skinny girls sat in a row of chairs,
fingering themselves, and the captions:
Garden of Eden and *Sweet Sixteen.*
My age. He was twenty-three.
The twist of my stomach, wrench to my throat:
going upstairs, we showered together
and I even shampooed his hair.

I remember his breath was bad,
me feeling special to see
where he dreamed, examining the pattern
of his flannel sheets. Black squares,
blue boxes. Black, blue, black,
blue. Squares, boxes.
Then he claimed my hand,
placed it hard on his penis; I thought
I don't feel right and told him so.
He threw off the covers and said, *I'll take you home.*
I remember thinking I'd done something wrong,
I'm sorry again and again.

II.

I followed him to his dresser.
He paused for a moment
before opening the drawer,
sunlight streaming through the window,
giving him a golden crown; I thought
God, is he beautiful.

I remember that instead of a pair of socks,
he pulled out a gun.
I remember thinking *I am not the kind of girl
who skips school, and then dies.*
I remember the panic that I could be.
He stroked the gun,
shifted it in his hand, the cool smack
of metal against palm. In my forest-green
wide-legged jeans and baby tee,
I prayed to whatever's above,
then said, my voice like hardened honey,
You said you'll take me home.
I remember he laughed
and set down the gun,
the icy valley narrowing in his eyes.
We tied our shoes.
The long silent ride home.

III.

That night, I microwaved meatloaf
and mashed potatoes my parents
brought home from the diner.
I poured everyone a drink.
I remember reaching for the gravy,
my mom saying, *I thought you didn't eat that.*
I shrugged my shoulders, folded my hands.
It was my father who always began,
Bless us, Oh Lord, and these Thy gifts.
I remember, for the first time,
it was me who led grace.

Fourth Grade Yearbook Photos

My mother couldn't wait.
She'd been planning my outfit for weeks,
so on Picture Day Eve, she wound my thin, flat hair
tightly around the rollers' pink sponge bodies,
just as she'd set her own.
She insisted that I sleep overnight in them.
I remember the tugs and bumps against my pillow,
and the swollen breaths of the moon
slipping past my miniblind.

The next morning, I put on the forest-green
floral dress with thick shoulder pads, black heels,
and tights. In her bathroom, Mom erased
my freckles and under eye circles with Cover Girl foundation
then concealer. Some mascara streaked my eyelid,
so she licked her finger and rubbed it clean,
painted my eyelids pink with a sponge brush
that elbowed my eyeballs, coated my cheeks
with cotton candy blush, and finished my face
with lipstick the color of strawberry Bubblicious.
She released my hair from the rollers,
delighting in the tightest curls, sprayed Aqua Net hairspray
until my hair was crunchy stiff and a sticky cloud
of chlorofluorocarbons loomed above us.

She unclasped her jewelry box
for the finishing touch: the gold leaf earrings.
My mother clapped at her creation:
me as a mini adult, a mini *her*.
My brother laughed as we waited for the bus.

I remember the puzzled stares and double-takes,
the smirks, and the teacher who told me I looked so mature
as I slunk down the halls of Windom Elementary
trying to disappear.

The next year, there was a calm quiet to my mother,
so she agreed when I announced
for this year's school picture,
I'll be wearing my red plaid pants.
No makeup or heels, my hair sinfully straight
and I said *cheeeese* for the camera that way,
flashing every bit of my overbite
and split front teeth.

My Mother's Mirror

Mom sits by her magnifying
makeup mirror, flips on its light,
opens the novel of her skin.
She writes: *I didn't go to the diner today—*
couldn't get out of bed. I'm no good lately.
I forget things and customers stare. I mix up words
and get slime around my mouth.

She traces each line with her finger,
stretches her skin to erase them. Dad whispers,
Your mother stares at that damn mirror for hours.
It would make anyone look ugly.
We watch Mom's finger drag
across her face then scrape
a splotch with her fingernails.
Every pore, crease, chin hair
is a child, naked and weeping
in the spotlight.

Mom, Mom, you're beautiful,
but her ears refuse to hear
and my words turn to tears,
something to touch
the way years wrinkle
and my mother buries her face
in the hands that raised me.

Dad's Morning Waitress

rises at 4 a.m., the time she used
to put her bones to bed.

In my high school yearbook, she wrote,
S, *Let's go out sometime. I'll drive. D,*
and the nights of wandering spelled out
our names.

All summer,
her spray-painted Bronco thundered silver
up my driveway—and that's how fast my world widened.
Feet on the dashboard, I'd ask, *Where are we going?*
She flicked me
her cigarette ashes.

I wanna get arrested, she said one night
as she blew through a red light,
see what it's like.

Our hearts are 10 years older.
The beats and breaths leave fast
and go where footsteps go.

Danielle never made it to jail.
She puts the open sign up at 5 a.m.
as my father flips bacon.
She wants Doug,
a regular complainer.
She goes to the gym everyday
to get smaller. She thinks Doug
will want her when she's small.
She stays past her shift to see him.
Cursive *Doug* on his welder workshirt.
His letters don't touch
except by accident.

He never learned cursive.
That's how he learned to write.
It's how he loves.

Danielle goes out for a smoke at 12:06
'cause Doug'll swing his truck round the corner
at 12:07, open the diner door for her at 12:08.
She pours his milk. Doug says, *Give me*
the salty chicken noodle. He gripes
then orders it, gripes
then orders it. But this time
she gives him chili. He says,
It's not what I ordered but I'll eat it.
And that's how he left chicken noodle.

Danielle tells me later, *All he does*
is bitch to me about his girlfriend.
When's he gonna wise up and be with me?
I'll wait. And that's how she got arrested.

New Song in Paris

She yanks her white turtleneck so she can breathe
just as he straightens his collar. She flicks her cigarette,
ashes fall on his shoes he rose early to polish.
Why did you go to the steakhouse alone? he asks,
hands in pockets, bending for an answer, and she explains,
painting his ear siren-red with her lipstick,
I'm a vegetarian, but I heard Le Petit Magot has
the best steaks. Now, I'm normally not the kind of person
who sneaks around, but last night I dreamed
everything was made of steak: my bed was one juicy steak,
my pillow was bloody rare, and the curtains were T-bones
blowing in the wind. In the center of the crowded plaza,
she outstretches her arms just as it begins to sprinkle, says
I love you, Paris, then turns to tell him, *Listen,*
I've grown tired of your same scratched song: up before 7,
hairs in the sink, milk in a frosted mug with every meal—
and the woman she was a second before is the raindrop
that washes the ash off his shiny black shoe.

Bread Knife Poem

And so / it has taken me / all of sixty years / to understand / that water is the finest drink, / and bread the most delicious food, / and that art is worthless / unless it plants / a measure of splendor in people's hearts.
—Taha Muhammad Ali

I once visited a home
in a dream of all places
where every day a different bread
sat holy beside a knife.

In this house you must use *only*
this knife to slice bread:
crusty loaves of Italian, sticky zucchini,
buttery naan, or even impossibly
dense stollen that confused
my taste buds as a child.

This knife *never* got washed,
as though removing the remnants
of bread from the blade
were a sin.

I was sure
this bread, this unwashed knife,
made the finest poem.
I bowed to it.

When I woke mid-line,
grabbed my coffee,
I carved it into
this full-bellied beauty.

A history of the most delicious food
told by a single knife,
seeds of splendor
bursting from our mouths
as we feast.

Closing the Diner One Night

I've married all the ketchups
and Wendell, a widower, is still struggling
to put the zipper pull on track
of his faded blue spring jacket.

His hairs are shoveled piles of snow
on opposite ends of a small backyard.
Beneath the thick ice of his wire frames
his blue ponds show no ripples.

It's warm out, Wendell, I tell him.
You probably won't need that jacket.
I wish he would leave it
two wings flapping in the wind

or drape the sad bundle of denim
over a forearm, toss it in the passenger seat.
He maneuvers the tab again and again
until a certain door swings open

and the slider glides to the old man's chin.
Thank you, he says, patting his pocket for keys.
Wendell turns to me and says,
I never get mad at anything.

Grandma's Last Visit to Our Red Diner

We're all sweating except for Grandma.
She's wearing a wool sweater with shreds of coleslaw
at a booth where she plucks chunks of haddock
from beer-battered skin. By the time she completes one bite
entire quarter pounders have been devoured.

Dad points out the window at a pink building
with splotches of grey. Last week it was still Bernadine's
dance studio. *I hear they're gonna paint it red*,
Dad says, and shakes the deep fryer basket
so that it rains grease.

Mechanic Dave says, *Yep.*
Building's commercial now,
as he swirls the ice 'round his glass.
He was my parents' first customer 25 years ago
when that building was my daycare.

Look at those stumps, I say.
Since they murdered those trees
I see wooden headstones
before a building of glassless windows,
sockets without eyes.

Grams shakes her head.
Her sunset-red lipstick
is setting on the rim of her glass.
But you can really see this diner now,
she says, then stares off

at a clown on a swing
hanging beside the doorway.
But red?
she laughs,
and some breading falls to her lap.

Don't worry, Grams, I say, and fetch
more napkins. *They can paint it red, and still
the only red in Woodlawn
is this diner
and your lipstick.*

Diner's Final Chapter

He disliked bars and bodegas. A clean, well-lighted café
was a very different thing.
 —Ernest Hemingway

Careful, this place is old, Dad would say
when I'd rattle our diner bones from shoving napkins
into holders and slamming their steel doors shut,
or lengthen the splits of the vinyl booths
when I kneel to wipe the windowsills.

Dad's worn-out these days, too,
scrubbing mugs because the dishwasher
slept in again. *Why not put an ad in the paper,*
I say. *That's how you found our diner.*
He shakes his greys and says,
Who'll keep it a diner?
Families just aren't the same,
and in this dead area . . .
He points to the empty lot next door
where the Rainbow Diner once stood.

We have to sell it to the right person,
my father always said, but we all know
that could take longer than his lifetime.

 (You know how before an old person dies
 you sense it's their final chapter,
 but you've yet to learn its thickness)

These days, each time I leave,
I push open the door lightly
the way I hug my frail grandmother
each time we say goodbye.

 (How you can feel bugs on skin
 from just the thought of them)

My skin slick with grease.
I can bring back my pissed-off skin
if I imagine sizzling bacon,
stainless steel splattered
with the pigs' last words,
my vegetarian stomach bloated
from just one whiff.

I picture the diner: shut down,
only the bones remain,
and we return as floating figures,
and see all the regulars: Onion Eddie, Eggs Bennie Debbie,
Old Fat George, Country Joe, Safety Pin Joe, Security Guard Richard—
as a child I'd stare at his gun.
I swear I could feel the bullets.

I enter, all the counter customers
swivel their seats around,
and when they see it's me, they say
Where you been hiding, kid?

Anti-Waitress Rondeau

Tonight I throw away my apron and spin.
I'm done, I say, to the coffee-spiller waitress.
Twelve years old she scribbled her first order,
Big Tim with the shiny belt buckle who tipped a rotten quarter.
I toss their dirty dishes in the bin—

I'm done with men who say that speaking up is sin,
and smiling when I hold myself together with hairpins.
Customers who dine like hoarders.
Tonight I throw away my apron.

I can't cure their heartache and hangovers. Listen,
there's not enough coffee and danishes
to make them feel like they don't need more,
and coffee always grows colder the second it's poured.
I craft myself a tonic and gin.
Tonight, I throw away my apron.

Prayer for Diners

For the bounty of coffee, conversation, grease-stained
newspapers strewn around counters and booths,
that the demolished diners' spirits remain.

For my father who hung his cook's hat, ate his mistakes,
for the beat-up and brokenhearted clothed in blues,
the bounty of coffee, conversation, and grease stains.

And the neon signs beckoning the stragglers
the way crosses pull the reverent to churches.
That the demolished diners' spirits remain.

Bodies rustier than antique cans, they limped in with canes.
For the jukeboxes too old for repair, songs that couldn't soothe.
For the bounty of coffee, conversation, and grease stains.

For today's specials, steel clanks, plate scrapes.
For the regulars who sat for hours unraveling their truths,
that the demolished diners' spirits remain.

Bless the names of the bodies that housed rivers of joy and pain.
Seasons trailed in by shiny shoes, sneakers, and work boots.
For the bounty of coffee, conversation, and grease stains.
That the demolished diners' spirits remain.

I Pour More Steaming Rivers

We need to talk, Joanne says
Friday night at The Plaka
as I scoop up tartar sauce
and drop the globs
into one ounce soufflé cups.

It's my fourth job in three months
since I said, *Dad, I love our little red diner,*
but I've been here all my life—
It was 12:15, what used to be lunch rush.
He was scrubbing platters as I sorted silverware.
I never thought my life would end up like this, he said,
and I remembered what he once told me, that his dream
before the diner was to pack up the van and drive
until a city felt like home.

Joanne's earrings dangle like running dogs
yanked when the chain goes straight.
Her eyes are pots of strong coffee
that sat too long on the burner.
My request-off days fold between her fingers.
I don't want to compete with poetry, she says.

I wish I could say that I told Joanne *It's no competition,*
releasing myself from this apron, and into the silk river sky
where stars are lanterns for people to float on,

but I picture myself wrinkled & grey,
slipping on tartar sauce. A carafe shatters
on the counter's edge, each shard a year of my life.
I get up, straighten my smock, make my coffee rounds.
But I no longer laugh at: *My eyes are turning brown* or
I'll float away. I wear their banter like varicose veins.

Sorry, I tell Joanne, then pour more steaming rivers
into thick sturdy mugs, anchors for lonely hands.
Coffee? I say, and the old man answers,
One more cup will hoist my sails, a line I've never heard,
so I grab my pen and write it down
like it's the only poem left.

driving jimmy home

it's like getting out of prison, jimmy says,
and flings off his apron. we bust out of the plaka
after customers missed every closing cue.
he's double my age, lanky,
what my mother would call a string bean.
we fill my jeep with haddock stench;
jimmy lights a cigarette. it's near freezing,
but we roll down the windows,
let the moon in.

slow night, again.
23 bucks in my olive green smock,
yoga pants painted with grease stains.
jimmy pulls a comb from his back pocket,
drives it through his wavy grey mane,
asks, *where will the night take you?*

i don't know.
maybe I'll work on a poem, i say.
earlier, the boss said, *let me see the broom*,
then demonstrated the correct way to sweep.
she wore flats and smelled of lilacs.
then she picked up a penny, huffed,
no one wants a penny anymore,
and i remembered a time when heads up
meant dreams and possibilities.

at 28 i've lost count
of waitress jobs and apartments.
jimmy's manned the plaka's grill since
the turn of the century.
i pull to the side of the street
before his crumbling abode.
he looks out the window, says,
i think i'll smoke a joint and watch tv.
i'm a creature of habit, always been that way,

and before he enters his house
he looks, for a long time,
at the moon

Saganaki Stories

At the Greek Taverna, we stock lighters
in our aprons and scream, *Opa!*
as we set flame to saganaki.
The customers cheer and clap.
Some of us—like the waitress who grabbed
the skillet instead of the wooden platter—
wear scars.

We work eight-hour shifts
breakless, sometimes thirteen
for hookah parties announced
last minute, so that nobody can take off.
We smoke hookahs in the break room
and claim we're only testing them,
slipping cell phones into pockets
when the boss sears in—

The boss is a prison warden
who summons us in the back to scream
before we start our shift. He's known by the last letter
of the alphabet, points his finger at each of us, hollers,
You have brain? Do you?—
Then take care of your customers tonight!
He holds a report of voided items up to a server's face, shouts,
You voided hookah. You're fired! Out of my restaurant—
Out! Z stomps away, and the waitress with tiny bangs
declares, *We've all been fired,*
sometimes several times a shift.
You need tough skin for this place.

I've got tough poet-skin, I think.
I'm here for the saganaki stories.
But if I get fired, I tell her, *I won't be back.*
A waitress packs a hookah tray
with grape tobacco, gets that dreamy faraway look,

says, *Z's so handsome when he yells*—
this scares me more than Z.
Later she rubs his back as another
pats his bicep, and what rots in my head
is his slimy smile.

And now, the blasting of Zorba's Dance,
our cue to pile our aprons onto the dessert case,
interlock arms, and dance across the dining room:
right snap, left snap, to the right *tap*, to the left *tap*,
tap heel *kick*, kick.

Z smashes plates in a giant bin as bussers
throw napkins at every table.
The bellydancer's coins clank as she smiles and shimmies
with immaculate rouge and lipstick.
A little boy demands, as he stares at her ass,
Lower, faster. His father claps and nods.

I put on that baby blue *Opa!* tee exactly ten times
before I was fired for someone else's mistake.
A manager relayed my side of the story.
He snapped, *I said she's fired.*

My last shift,
our bartender starts the birthday song.
I sing louder this time, the servers tossing
napkins that won't get recycled. I make it rain
wasteful white papers until I am empty,
wearing no trace of these saganaki stories
when I bust out the door, the last letter
ground beneath my heel.

Lucky Dog's Hot Dog Joint

In every all-night diner
someone is staring so intently into their coffee
that the cream settles into a map of their life.

At the hot dog joint
an old man coated
in dirt & dried dreams
is hunched over a mug, mumbling.

You've seen him—
person on his own island,
only empty seats surround him.

Hungry from drinking & dancing,
Anna darts down Allen Street. Beer cans clank
in shopping carts; the street wears potholes
like a teen with acne.

Anna sits next to him.
Rests her cheek in her palm,
blonde rivers spilling through her fingers,
says, *How's your night been?*

Just killing time, he says,
and pulls out a handkerchief.
Trying to get to the veterans' hospital;
next bus don't leave 'til mornin'.

He pours cream into his coffee, circles a spoon,
stirring the swirls of his life.
You know, he says, *when we got back from Vietnam,*
they spit at us. She places her hand on the eagle
embroidered on the back of his jacket.

Forgive my chewing, I got no teeth,
and he chomps his gums down hard
into the chili dog, soggy bits of bun & sauce flying
from his lips. Anna says, *Dig right in*
and, hey, you've got dibs on my fries if you'd like.

Graveyard Shift

I return from work, feet throbbing
from having served so many drunks.
I'm in an apartment that I recognize as mine
but the objects feel distant: sound asleep.
The hardwood floors are cold coffin lids.
I light a candle but the wick's too short
so the flame shrinks back to darkness,
and my lover, diluted in dreams,
will not depart from sleep.

I believe the dark mouth of this night
could swallow me, take me off to some foreign place
so I pay attention: clock says 6:57,
walls gape from fist and nail holes,
and the faucet sheds tears on the stainless steel sink.

I'm slightly outside this world,
as I imagine it might feel to be dead,
still part of the whole but somewhat off-center
the way the peel must crave
its juice from the orange, and I worry

that the light will grow outside my window
before I have made it to sleep, so I shut the curtains,
put on my sleep mask, yank the covers over my eyes.
Stopping the poem—

Morning on the Subway

A man with a mouth full of bagel
reads the paper, wipes crumbs
off lips, inspects his plain red tie.

He is still covered in sleep, cheeks rosy
from dreams, but he flips the pages fast
to prepare himself for work.

I can't leave the front page.
I'm crying and cradling the grey-haired worker
trapped in a black & white photograph.
Short & round in suspenders and boots,
he hunches over a push broom,
sweeps the blood off the sidewalk,
last night's gun shots.

I squint to see his face, the darkest spot.
His mouth, a shriveled plum sliced open,
eyes halfway closed.
He shakes his head and sweeps,
shakes his head then weeps.
He wants to go back to the dreams
he had as a boy.

The subway stops and everyone
sways. A boy with headphones points
there. The man who ate the bagel stands;
crumbs stab the floor.
The ants all scream.

Danielle's Dolphins

I.

You left on the Fourth of July—
figures you would exit this world with a bang,
the sky streaked with shrieks of color
so that even your death was a grand finale.

II.

Let's drive somewhere, you'd say,
counting your tips from the morning shift
then scrunching your soup-caked apron.
And we'd hop in your beat-up Bronco,
(it was always you who drove)
raid a 7-Eleven, find ourselves
beneath a sea of stars in a field, or we'd climb
a giant lifeguard chair at some beach past a sign
that says: *Closed at Dusk.*

You were the one giggling and cracking open a cold one;
I was checking for shining flashlights and black suits.

III.

We're in our mid-thirties when
you drive twenty hours to visit.
I click on your fundraiser and learn
it's your end-of-life trip.
You're my only Facebook friend
without a profile picture.

I'm driving us to see the dolphins
(I know you're in pain by how carefully
you shift your body)
when you tell me you never understood

bodies in boxes, yours
will be donated for research, then after,
ashes planted in a seed pod
to be a tree in your sister's backyard.
If she moves she better take me with her, you laugh.

Sky darkening, I check the time
every few blocks.
You've got to see the dolphins,
I say. It seems necessary. You say you're happy
either way, but I've seen years
of the simplest things excite you.

IV.

At the sea wall where you stand,
the dolphins come right up to you.
You exclaim: *They flipped around
to show me their stomachs!*
I tell you they came for you;
you believe me and tell everyone this story.

V.

It's the story your sister tells you,
unresponsive, three months later
on your deathbed. You depart just as it ends.
That's how she knows you were listening.

VI.

You told me you wanted to come back
as a spoiled house cat or mermaid,
but I see you as a dolphin.

Days after your death,
I went to our spot hours past sunset
and asked, *Danielle, are you there?*

and just then the wind changed directions
and made the light rain hitting the water sound
like God playing bell chimes across the bay.

I yelled again,
Are you there?

At that exact moment
you revealed
your curved slippery body.

My Mother's Fireflies

Mom asks what my new poem is about
as I chew a broccoli crown. *Fireflies,* I say,
but before I can tell about the time—

Mom throws up her hands and says,
Fireflies! When your father and I first met,
we were driving down dark winding roads
and suddenly, our car was filled with fireflies.
Dad throws his crumpled napkin
onto his plate of bones. *Okay, sure Joan.*

I ask Mom: Was the car parked?
Did they fly through open windows?
How many were there? She says,
So many! They just flew right in
and filled the spaces between us.

So what if my mother's story is true.
It goes like this: When my parents were first
in love, my mother saw fireflies, embers,
or pieces of moon—she saw lights, tiny lights
and so many. She looked at them and knew.

Potato Salad at Midnight

You're at your childhood home your parents are scrambling
to sell, to help erase three decades' clutter. Your mother,
on top of the world these days, is up stretching her legs
with a huge grin as you're scooping yourself some potato salad
in the still-quiet night. You're tasting it and telling your mother it's better
than your dad's. Your father comes into the kitchen like the eye drop's journey
bottle to eye. He's here to retrieve your mother,
who really does need sleep even though she hardly believes it.
Your father is serious, so serious. *Good potato salad*, you say,
and think: this is a play and we're all actors. Let's shake off this heavy air,
erupt into raucous laughter. Usually you stay in the kitchen to form an alliance
with your bright-eyed mother, but this time, you disappear into your room
where your husband Thaddeus sleeps.
You kiss his marvelous forehead,
 and the stiff air falls softly
 like the season's
 first
 snowfall.

The Day They Demolished the Blue Diner

Snow sprinkles bundle Buffalonians. I risk the icy sidewalk to say goodbye.
The only diner in the Elmwood Village: the small blue Greek joint where I fell

in love with the cook three Januarys ago, before I left for grad school.
I ride the heels of a man lugging a bulging laundry bag over his shoulder.

He glares, but I don't care because the diner's pulse is dwindling,
and I can't arrive fast enough for one last coffee at the counter, to hold

the diner as through it were a face I could press my forehead against
one last time. I sit by Kenny, order a feta omelette, scan for wounds—

the boarded-up back door and pass-through window, the kitchen moved up
a flight to become StairMaster for the new line of skinny & hip servers. I used

to admire my lover's hands as he pushed plates through that now-vanished
window. Tomorrow they'll come for the counter. The blue diner will be a bistro

with TVs, DJs, nightly drink specials, smaller plates with higher prices,
pomegranates on pancakes. I sip my coffee. *This is it,* Kenny says, and slaps

his hand on the counter. Bob from the flower shop next door shakes his head,
says, *What a shame.* His cordless phone and newspaper hold down his fort

so that he can go back and forth from shop to diner all day. I finish
my coffee and slide my thick empty mug to the edge of the story.

Sunshine Woman

I wear a bird in my hair. It's teeth
fall out—that's the point, too tiny
to notice. —Lake Angela (Sunshine Woman), "Late February"

In a city full of closed signs
we'll write on the balcony
lines of poems that sometimes lift
like paper lanterns.

You make decaying things shimmer,
your blue cockroach collarbone tattoo
glinting in the sunlight. Two glasses of red wine
sit on a small black circular table. We'll swirl then sip,
always the red, because you say

it looks like blood, and that delights you.
We'll drink until we lose the lake of our bodies.
Look, I know we can't always stop the neon green light
that follows you with a bag of your breath,
but once our lips are good and stained

we can belt out the lyrics to "A Total Eclipse of the Heart"
flinging our bodies to the mountaintop-rhythm
until your hunger is big enough
that you'll eat a small bowl of ice cream
where you'll dig for all the chocolate pieces

and laugh about it.
When I can't find you, let it be because
you're lying naked in the grass, and smiling
because that's what you like to do.

Listen,
there are a thousand ways to keep on dancing,
and
it's not nearly time to become a bird.

Grams Dances the Charleston

I clip her curled, crooked toenails
and say, *Grams, tell me a story about you.*
Her skin, a shawl of dried orchid petals.
Ice cream melts arabesques in her coffee.

She smiles,
clouds drifting from her lips:

Once upon a Christmastime,
when I was five years old,

Mother took me downtown
to search for a red dress.

I saw Santa, so I slipped
my hand from hers and ran.

Grandma sways her finger as she speaks
as though pressing the piano keys of air.
Did you sit on Santa's lap? I ask
and she strikes a key: *No,*

I danced the Charleston, 1-2-3-4-5-6-7-8;
1-2-3-4-5-6-7-8, and people gathered and clapped

until my mother yanked
me by the wrist—

She cradles her mug
with both hands,
leans forward and reveals,

I knew just how to swing my legs
because when visitors came,

my mother rolled out the red carpet.
I watched them dance from the staircase,

my face between
the spindles.

When every last nail is filed,
I slide on her crimson slippers.
Maybe you'll write a poem about this, she says.

In my poem,
this is what happens
when Grandma's skin is new.

After her mother grabs her wrist,
Grams keeps on dancing
and everyone stays gathered around
cheering, *My can she dance* and
Look at her dance—

Grandma, when I see you glissade across rooms
with a walker, dress and red lipstick,
it is clear to me:

some people never stop dancing,
skin forever abloom

How Simple Steps Become a Dance

1.

What does Grandma think about
now that she is old? She sent me a letter
addressed to Sara Free Verse Ries.

She reported mostly about the weather,
but she did write: *I don't like the peace sign you drew*
on the last letter. It looks like a broken cross.

2.

Lauri scrubs food off her apron
as I eat pepperoncinis in the Pie Room.
It was a full house in my dream
last night, she says. *All the customers*
glared, waving their hands, stamping
boots, raising empty glasses.
We smooth our aprons.
I dream that too, I say,
and we each lift a coffee pot,
fill what we can.

3.

I wrote the words knowing the great distance
between Buffalo and Grandma's delicate hands in Tampa.

I wrote, knowing my words do not have wings
and I will have to drop the letter into the mouth

of a blue box. For you, my grandmother,
I drew hearts, only hearts.

4.

Why do you always want to blend everything? Dad asks
at a Poetry and Dinner Night in the kitchen of our diner.
He has filled the plates with meatloaf and mashed potatoes
and is waiting for me to serve them. I'm by the twirling steam,
somewhere else.

5.

I kiss you, Thaddeus, after you've been sailing,
our cats asleep on our aprons from the morning shift
at the small blue Greek diner.
You smell like wind and water.
Let me stay here, right here.

6.

To be a waitress—a good waitress—
is to let thank-yous slide off your tongue until
it is not just thank you for a tip or a reply to *Have a nice day*,
until they become a wish for the people outside this window,
that they will share umbrellas in the good rain, and for my own two feet:
make them a small sailboat, and when I close my eyes,
puddles beneath.

7.

I want an old greasy couch found
on the side of the road
with cushions that sag
from holding the full weight of people—
Maybe then I could rest.

8.

Grandma, after you flew back to Florida at the end of summer,
I decided to eat an unstirred fruit-on-the-bottom yogurt,
the way you do, *saving the best for last*,
no sweetness to lighten the sting of the sour white.
And it's cold and long like winter.
I never know if you'll make it to next summer
to spend afternoons at our diner and sip lemonade
in dresses brighter than wildflowers.

9.

Shoved to another season:
I dig through bins
for thick things to cover me.

Leaves watercolor the streets.
I mistake stems for worms, jump over them
on my walk to visit a friend.

Her hands circle a mug. She says,
Summer went by so fast.

I take another sip of tea, ask,
Is this how life happens?
This sudden—a fast unfurling of scarves?

10.

I'm a good waitress, Lauri says.
I quit my last job because the owner said
waitresses are a dime a dozen.

He doesn't understand waitress rhythm, I say,
how simple steps become a dance.

11.

The writers stare
 out windows,
 journals on laps,
 coffee on stands. Clock hands
 traveling
 worn circles.
 Out here,
 it's just snow and the number of breaths it takes
for a snowflake to land
 on parking meters, trees,
 this page.

12.

Grandma, teach me to play piano
 so I can press the keys and learn the sounds,
 whole sounds, when they're not wearing words.

Prayer at Johnson's Corner

I order an omelette from a truck stop diner
in Loveland, Colorado,
two hours before a plane will take me
away from the Rockies.

I wipe lipstick off my mug.
I imagine a lady sits here every morning
and eats poached eggs. After another cup of decaf,
she paints her lips, says: *I know I'm old,*
but I'm nowhere near ready to leave—

The waitress refills my coffee; it splashes
outside my mug. She shakes her hair more grey
through whiffs of bacon, says *I'm not with it.*

I do that too, I say. *I'm a waitress.*
She looks out the window and pauses
as if the mountains just whispered:
Coffee spills are tiny decorations.

I come from a diner in Buffalo
and any exit will take me back.
When I look out my window after I spill coffee,
the only mountain I see is a closed steel plant.
Now our diner gets more coffee stains
than customers. But sometimes,
behind barbed wire, geese lower
their beaks to grass.

I check the time, button my jacket.
A man at a booth scrawls something
on his paper placemat. He wears
black boots, leather vest, jagged beard.
The waitress serves him steak.
He takes off his hat, bows his head
folds his hands, closes his eyes

and everything:
the mountains, steel plants, flesh, the full loaf
of it all—become soft and they flow into
each other and then
he opens his eyes.

Grandmother of Our Diner

from The Buffalo News' *article, "80 years of hot coffee
and hospitality at the Woodlawn Diner"*

The years stand still
no matter what
the neon-rimmed clock does.

Mary's diner in the 50s:
hot coffee, 5 cents a cup. Daily specials
under a buck. Bacon sizzles to the swoosh of an over-
easy—a symphony. Truckers' favorite: big plate
of beans and a couple of wieners—*sold out*. Elbows
planted, hungry steelworkers chow down towers
of flapjacks, leave their grooves in the counter.
The stainless steel sparkles.

Mary lives behind the diner she built.
Mary's presence—*constant*.
Mary checking soups in the steam table.
Mary sipping coffee in her favorite booth
by the cash register. Mary in pointed toe
high heels to kick the help in the behind.
Mary delivers coffees
to first responders at working fires.

Mary runs the diner on her own for decades
after the divorce. Her ex-husband opens another diner
down the street, names it Belle after his new wife.
Meet and eat at the Woodlawn Diner.

Later, when her daughter gets good grub
at a high-back booth, the stainless steel
still sparkles. Melancholy
when she sees Mary's picture on the wall.
It was ours at one time. . .

Future Owner

In a diner where few women eat,
and even fewer
 eat alone,
Missy stopped by some mornings.

 Perhaps Dad was feeling extra achy that day,
or it was the way
 the sunlight skated
 across her side of the counter,

so when napkins were crinkled on her yolk-smeared plate
Dad turned from the grill, wiped his hands on his apron, asked,
 Where you headed?

Subway, she said. *I manage four shops.*
Dad's face lit up.
 *So owning a little place like this
 would be a cinch*
and she exclaimed,
*A place like this
is my dream.*

(It was my parents' dream too. Mom beamed
every time she told a customer their story.)

Look for people with their lights on,
my father always said;
 he saw them
 moon-bright
 in Missy.

Now Missy's picture hangs by the ice cream freezer
below my parents when Dad sported sideburns
and Mom's hair was two long curtains framing her rouged cheeks.
The top photo: *Grandmother of the Diner*: Mary in a white dress,
hand on hip. She'd fire a waitress for a coffee missing from a guest
check.

*

I'm swinging in a hammock on my balcony
in Villa de Leyva, Colombia,
when my phone, smaller than an empanada, rings;

 Dad tells me
he and Mom sold the diner.

Before we hang up, I say:
 How can the diner not be ours anymore?
 He responds

Well, it was Mary's before we owned it,
and it's Missy's now.

The horses carrying tourists
 down our cobblestone street
 trot
 in slow motion.

 The diner goes on
 without us.

For Papa Emile Latimer

(1934 -2013)

February 2007, Buffalo, NY
He graced our diner's counter in an orange scarf
and black beret where I married ketchups. Splatters
of dirty snow puddled, what snow globes never show.
Soon, somebody would be told to get the mop.
But let's get back to the man whose eyes glistened
like a fresh snowfall. Everybody called him *Papa*.
He was a master of African hand drums, mentored
countless musicians, played guitar on tour
with Nina Simone in the sixties.

I didn't know any of this yet. I was serving him baked fish
when he asked, *How will you celebrate Black History Month?*
and although I hadn't thought about it, I said, *Read some*
Langston Hughes and Maya Angelou
so as to not disappoint him.

He leaned back, studied my face.
He told me Rumi lives in his home,
then we recited lines from the great mystic poet.

I returned to my role as waitress, asked, *How's the fish?*
He gave me the slightest nod. Such questions were bones
in the haddock. We returned to art and poetry and the lights
clicked back on. I scribbled these lines on a piece of register tape:
 I waitress for these conversations.
 Small talk is when words hitchhike—
 They will let any mouth transport them around.

February 2020, St. Petersburg, FL
In the full-mouth middle of night,
my husband, who played music with Papa in Buffalo,
sits beside me after I nurse our newborn son.
We watch the video of Papa singing his song: "Black Is the Color
of My True Love's Hair" at the Lincoln Center in the Big Apple
as Nina plays piano. He is shedding sheets of his soul as he sings
Black is her beauty, her soul of gold. They learned they both wrote
a song with that same title so Nina said, *You'll sing that in my show.*

This year, Papa Emile lives in our home and we remember
how he illuminated our grey Rust Belt City, how his hands
would give breath back to the goat skin of the djembe,
how he'd make the dark sticky insides of bars feel
like Sunday afternoon sunshine.

In a dream, between sips of tea, he asks me
what I am doing for Black History Month.
I lean back to catch the spark in his smile.

Watching My Father Work

*What terrifies / me most is / how we foam / at the mouth / with envy /
when others / succeed / but / sigh in relief / when they / are failing*
—Rupi Kaur

Dad shakes his head, says,
I swear some customers wanted me to die in the diner.
They seemed mad I retired. Others thought I had it made.

Now, eight states away from the blood-red diner:

my aunt and her boyfriend visit.
The boyfriend studies the oil painting of our diner
that hangs above my aunt in gleaming red, says,
Yeah, I'd stop in your folks' diner, sit at the counter,
order the #7. Your father always there, buttering toast,
scraping that spatula at top speed.

He downs more coffee, says,
I used to love seeing your father
work his ass off.

He leans back, folds his hands.
A light dims in his face.
But now I know, he's done well,
a lot better than me. Yep,
he's a smart businessman.

The sandwiches are ready, so we eat.

I want to tell those people
who loved watching the well-oiled machine—
that was my *father.*

Today we inhabit different cities
far from the diner, but customers push through
the swinging door of our minds, stomp dirt or snow
off their boots, and these customers
are *always* hungry. We jump up—

go back to your favorite seat: brown booth
or green stool where you ordered your short stack and coffee,
fried bologna, or today's special.

See him: red-faced
and stiff-shouldered, flying back
and forth from refrigerator
to grill, my mother, brother, and I scramble
to keep the pace without snags,
broken dish or forgotten side.

Urge him to take it easy.
Say: *Slow down, Dave.*
Are your spatulas on fire?
We have all damn day.

Family Diner's Facelift

Antique cans swaddled in greasy garments of time,
boxed with the Norman Rockwells, penny candy jars
I'd Windex on slow afternoons when all the stainless steel
shined. Fresh paint where the gallery of past owners hung high
above the ice cream freezer: gone. *Ghosts.* The grill banished far
from workers' stories that burn in memory of steel mills.
Soups, gravys, and corned beef hash—my father's recipes
remain, his poems, written for 32 years with hard
spatula scrapes behind the counter. Today I request a refill
and stare at string lights where a payphone once rang dreams—
now still.

Come In, We're *Still* Open

says the sign in our diner's window
during the pandemic when dining in
is banned. In dreams
like this one, my parents still run
the diner. Dad's at the grill, and Mom
is convincing someone to order something sweet,
 to *live a little.*

Our diner is the color of blood
or candy apples
depending on the light's
 blushing lace dress made of snowflakes,
neon sign beaming a halo
beckoning its wanderers home.

 Duke and Country Joe are sitting at the counter
behind my father, who's sawing
through a stack of toast.

Duke says to Joe (because the dead are
alive in dreams) *The diner* is
an essential business.
 It's why my heart still beats.

The customers all wear facemasks,
and Mom and I can't jot down
 their orders fast enough.

 I thought I'd moved on
 from delivering #1s and 2-2-2s
to the rhythm of sizzling bacon, grill scrapes,
 the hiss of coffee brewing
the ding-*ding*
of the register,
 another guest check pierced by the spindle.

Steel Worker Mike is at booth seven
with no sign of cancer,
newspaper spread before him like crinkling wings

and when I pour him two cups at once
because his preferred temperature for coffee
is the cooled one

he looks up at me and says,
 They're dropping like flies out there.

We All Go Back

Mary ran the little red diner for 50 years.
Skin and bones in the nursing home
she begged my mother *please* please
take me back to my diner, to the plate scrapes, clanks.

Mary tried to escape that home till she was just bones,
the diner music pulsing strong in her ears:
she never made it back to the clink-clank-scrapes.
For 32 years, my parents' palms warmed the keys.

Diner music thrummed full houses in their ears;
they covered any shift, even pandemic pre-vaccine.
After a triple decker of time, Missy carried the keys
and for 6 years, she kept the diner's heart ringing.

Dave & Joan *still* cover any shift gripped with aches.
Missy sold the diner, stayed on as the new owner's cook.
For a side order of time, she made the diner's heart clang.
I'm a daughter of the diner; I crave chatter and grease stains.

Missy can't stay away; she's Keith's head cook
and I will forever go back to my family's red diner.
Born of the diner, my jam is chatter and grease shine.
In dreams I'm back in my apron, pockets full of jingling coins.

Acknowledgments

Poems in this collection have appeared in the following publications, sometimes in earlier versions, and I gratefully acknowledge these editors:

Blue Collar Review: "Dad Taught Me Poetry," "Graveyard Shift," "Saganaki Stories," and "How We Said Goodbye"

Cathexis Northwest Press: "Lady at the Counter," "Prayer for Diners," "driving jimmy home," and "the customers never saw"

Cordella Magazine: "Fish Fry Daughter Returns," "My Mother's Jet Plane," and "Postcard from Scott Spencer"

Creative Pinellas Arts Coast Journal: "My Mother's Mirror" and "I Explain to the Guy at Counter Eleven"

Earth's Daughters: "My Mother's Fireflies"

HerWords (Black Mountain Press): "Grams Dances the Charleston"

Lily Poetry Review: "Closing the Diner" (now titled "Closing the Diner One Night")

LABOR: Studies in Working-Class History of the Americas: "American Cheese Family"

Neptune Magazine: "For Papa Emile Latimer" and "The Diner Is Up in Flames"

Potomac Review: "Family Diner's Facelift" and "Diner's Final Chapter"

Steel Bellow: "Racecar Dad," "New Song in Paris," and "Morning on the Subway"

The Artisan Magazine: "Danielle's Dolphins"

The Broadkill Review: "Our Diner's Red" and "Woman Truckers' Poem"

The Buffalo News: "Sunshine Woman, a Quarantine Poem" (now titled "Sunshine Woman")

Waterwheel Review: "How Simple Steps Become a Dance"

"Potato Salad at Midnight" was included in a previous collection, *Snow Angels on the Living Room Floor*, (Finishing Line Press, 2018)

"Ketchup in My Veins" appeared on the *I Am From Project*'s website

Anthologies:

A Celebration of Western New York Poets: "Prayer at Johnson's Corner"

Brigid's Fire, The South Buffalo Anthology of Poetry: "The Urine Couple"

Just Twelve More Poems and Other Works: "Teenage Waitress," "I Pour More Steaming Rivers," and "Cigarettes, Meat Fat, and Ice Cream"

<p align="center">*</p>

I am grateful to Press 53 publisher Kevin Watson and editor Tom Lombardo for the wonderful work they do to bring poetry books into the world and for believing in mine. I am extremely grateful to Lake Angela, for her expert editing suggestions for nearly all of these poems and for always having my back; Mary Chris Bailey for reading the final manuscript and finding ways to make this book even better. Special thanks to the members of my Lit Garden Writing Group and

Goddess Writing Group for their close examinations of these poems from their various stages of revision; to Jim Daniels, Michael Simms, Lola Haskins, Lake Angela, and Michael Engle for providing blurbs; to the Buffalo and St. Pete poetry communities; and for all the people, too many of you to name, who have helped and supported me along the way. Lastly, a gigantic thanks to my first reader, my dear Thaddeus, who has provided such steadiness even in the chaotic moments of life.

—SRD

Sara Ries Dziekonski is a Buffalo native and holds an MFA in poetry from Chatham University. Her first book, *Come In, We're Open*, won the 2009 Stevens Poetry Manuscript Competition. Her chapbooks include *Snow Angels on the Living Room Floor* and *Marrying Maracuyá*, which won the Cathy Smith Bowers Chapbook Competition. Her poems have appeared in U.S. Poet Laureate Ted Kooser's syndicated newspaper column "American Life in Poetry," and in the journals *Slipstream*, *Potomac Review*, *SWWIM Every Day*, *Connecticut River Review*, and *LABOR: Studies in Working-Class History of the Americas*, among others. Ries Dziekonski is the co-founder of Poetry Midwives Editing and Submission Services and teaches creative writing for Keep St. Pete Lit. She lives in St. Petersburg, Florida, with her husband, two kids, and cat.